Praise for *Wing Over Wi...*

"This book is a treasure, the work of ... has opened my eyes to my own life and the life of the world. Julie Cadwallader Staub has a gift for finding the holy in nature and human nature—in the choreographed flight of birds and in a chance meeting with a homeless man. At a time when our public life is so squalid and shameful, we need voices like hers, voices of clarity and compassion, to remind us of the human possibilities that are forever within us and between us. *Wing Over Wing* is a collection to sustain our spirits, ignite our imaginations, and help us reclaim true north."

—**Parker J. Palmer**, author of *Let Your Life Speak*

"Julie Cadwallader Staub writes with a curious eye and a grateful soul, finding comfort and revelation in metaphor, parable and lush loving alliterative sound. *Wing Over Wing* offers a way to live with meaning, grace and an ever-hopeful heart tuned to healing and discovery."

—**Naomi Shihab Nye**, author of *Tender Spot: Selected Poems*

"Julie Cadwallader Staub has a fine ear for what she calls 'the language of trees.' These poems unfold with a rich, deep music. The poet inclines her ear to the mysteries, and she finds them everywhere, in the least expected places."

—**Jay Parini**, author of *New and Collected Poems, 1975-2015*

"These poems invite you to witness life's precise, essential moments: a mother's curlers, a child's bath time, a husband's last breath. They are poems of praise, sorrow, reverence and deep love, and they'll grip you and spin you round with gentle insistency. Look! They seem to say, and: Look again! Every poem brings you round a bend in road, river, or memory to see with new eyes even the most familiar of vistas."

—**Miciah Bay Gault**, author of *Goodnight Stranger: A Novel*

Paraclete Poetry Series Editor

Mark S. Burrows

POEMS

Wing Over Wing

JULIE
CADWALLADER
STAUB

PARACLETE PRESS
BREWSTER, MASSACHUSETTS

IN LOVING MEMORY OF
my parents and grandparents

2019 First Printing

Wing Over Wing: Poems

Copyright © 2019 by Julie Cadwallader Staub

ISBN 978-1-64060-000-3

The Paraclete Press name and logo (dove on cross) are trademarks of Paraclete Press, Inc.

Library of Congress Cataloging-in-Publication Data
Names: Staub, Julie Cadwallader, author.
Title: Wing over wing : poems / Julie Cadwallader Staub.
Description: Brewster, Massachusetts : Paraclete Press, [2019]
Identifiers: LCCN 2019020951 I ISBN 9781640600003 (tradepaper)
Classification: LCC PS3603.A374 A6 2019 I DDC 811/.6--dc23
LC record available at https://lccn.loc.gov/2019020951

10 9 8 7 6 5 4 3 2 1

Published by Paraclete Press
Brewster, Massachusetts
www.paracletepress.com

Printed in the United States of America

CONTENTS

PART I: Fall

Longing 3
Midlife 4
Route 100 5
Turning 6
Blackbirds 7
In Whom We Live and Move and Have Our Being 8
Moth 9
October 10
Lesson Before a Road Trip 11
Ave Verum 12
Entry in his journal, eight days before he died 13
Close Your Eyes 14
Planting Crocus on His Birthday 15
Milk 16
Pie 17

PART II: Winter

Swing Low 21
Dying 22
A Few Moments 23
Whistle 24
The Murder of Carol Jenkins in Martinsville
 Indiana in 1972 25
ISIS 26
Little 27
again and again 28
Praying 29
Thumb 30
Sorrow 31
Maple Seed 32
Verdaccio 33
Winter Sacrament 34
Love 35
Be Not Afraid 37
Christmas Eve 38
Word to Wing 39
Slow by Slow—I 40

Part III: Spring

Hinge 45
Amtrak 46
Naked Hour 47
Two Poets 48
Ode to Salted Caramels 49
Progress 50
Slow by Slow—2 51
Mercy 52
Measurement 53
Birding by Ear 54
Can You Imagine 55
Jesus Buys a House in South Burlington, VT 56
Boulder 58
Staple 59
Teach me about trust 60
Mallards 61
Sounding 62

Part IV: Summer

Trees 65
Comfort 66
Time 67
Recipe 68
Remember 69
Looks 70
Mothers 72
A Mother's Response 74
Kiki 76
Judge 77
Map 79
Letting Go 81
Paradise of Light 82
Shine 83
On the Bus 84
Late August 86
Reverence 87

ACKNOWLEDGMENTS 88

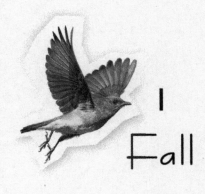

I
Fall
—

"If there were no other proof of the existence of a bigger reality than birds, they would do it for me."
—Anne Lamott

Longing

Consider the blackpoll warbler.

She tips the scales
at one ounce
before she migrates, taking off
from the seacoast to our east
flying higher and higher

ascending two or three miles
during her eighty hours of flight
until she lands,
in Tobago,
north of Venezuela
three days older,
and weighing half as much.

She flies over open ocean almost the whole way.

She is not so different from us.
The arc of our lives is a mystery too.
We do not understand,
we cannot see
what guides us on our way:
that longing that pulls us toward light.

Not knowing, we fly onward
hearing the dull roar of the waves below.

Midlife

This is as far as the light
of my understanding
has carried me:
> an October morning
> a canoe built by hand
> a quiet current

above me the trees arc
green and golden
against a cloudy sky

below me the river responds
with perfect reflection
> a hundred feet deep
> a hundred feet high.

To take a cup of this river
to drink its purple and gray
its golden and green

to see
a bend in the river up ahead
> and still
> say
> yes.

Route 100

Somewhere south of Center Fayston,
Route 100 drops
between steeply forested hills,
their luscious greens already curling
toward crimson and gold.

Mine is the only car
on this pocket of road
and I am suspended
in September's colors,
mesmerized by autumn's
clear and changing light.

I barely register
the dead skunk in the road ahead
before its solemn, conclusive thump
under my left front tire

and now that sharp scent
punctuates my every breath:
its tang of wildness
its slap of mortality.

Turning

There comes a time in every fall
before the leaves begin to turn
when blackbirds group and flock and gather
choosing a tree, a branch, together
to click and call and chorus and clamor
announcing the season has come for travel.

Then comes a time when all those birds
without a sound or backward glance
pour from every branch and limb
into the air, as if on a whim
but it's a dynamic, choreographed mass
a swoop, a swerve, a mystery, a dance

and now the tree stands breathless, amazed
at how it was chosen, how it was changed.

Blackbirds

I am 52 years old, and have spent
truly the better part
of my life out-of-doors
but yesterday I heard a new sound above my head
a rustling, ruffling quietness in the spring air

and when I turned my face upward
I saw a flock of blackbirds
rounding a curve I didn't know was there
and the sound was simply all those wings,
all those feathers against air, against gravity
and such a beautiful winning:
the whole flock taking a long, wide turn
as if of one body and one mind.

How do they *do* that?

If we lived only in human society
what a puny existence that would be

but instead we live and move and have our being
here, in this curving and soaring world
that is not our own
so when mercy and tenderness triumph in our lives
and when, even more rarely, we unite and move together
toward a common good,

we can think to ourselves:

ah yes, this is how it's meant to be.

In Whom We Live and Move and Have Our Being

It's October.
Snow geese fly far above the trees in sleek silence.
Canada geese circle noisily above the stubby cornfield.
White pines drop their needles through the clear air
transforming the forest floor into a golden carpet
between one day and the next.

And beneath all that motion lies
mile after mile of aquifer,
acre after acre of unmoving rock
sturdy enough to support this forest
but porous enough that water seeps, squeezes,
filters its way
pore by careful pore.

And who can say which is more amazing
the golden needles
the clear air
those soundless snow geese

or the idea of rock so immense
it upholds this paradise
and so permeable
each drop can find its own way.

Moth

When Jesus said, *"Suffer the little ones to come unto me"*

I know he included this inch-long moth
marooned on the bike path
gray wings delicately trimmed in white
a neon-orange head
an iridescent-blue body.

When I put my fingers down in front of it,
it climbs right into my hand,
happily, I think,

and when I crouch at the edge of the path
to let it go
there is a young apple tree growing there,
sensitive and wood ferns,
buttercups,
a spray of little white asters

for such is the kingdom of heaven.

October

Like days off the calendar
leaves hurtle through the air

then, with a twitch of tail,
tilt of head, one leaf
reveals itself:

a dark-eyed junco
riding the wild wind home.

Lesson Before a Road Trip
—for Warren

He begins to fill
the windshield
washer
recep-
tacle
and immediately three children
cluster at his elbow,
yearning to help,
afraid of spilling.

With a single sweep of his arm, he pours the blue fluid
from one side of the engine to the other, then hands
the jug to the child
nearest him.
Here, he says lightly
You try.

Ave Verum

I left the kids
to snacks and homework,
drove to pick up my husband
from choir rehearsal

leaned against the doorway, tired
watching as members of the choir chatted,
folded their chairs,
upended and passed them
hand over hand
forming a ragged assembly line
to the closet

when someone started singing

Jesu, Word of God incarnate

and the whole room hushed
took a breath
and broke open
into four-part harmony

of the Virgin Mary born

the assembly line slowed, aligned
itself with this somber rhythm
and there was my husband,

thinner than he had ever been
but not as thin as he would become
singing, bending, lifting

on the cross thy sacred body

Entry in his journal, eight days before he died

I was weeding, in a huge vineyard. Everyone was tired, but happy to be there. It was lush, deep green and plants were on 3' A-frames that covered acres and acres of rolling hills that seemed to go forever.

It was the end of the day. Orange light of the setting sun made the green more rich and the whole scene more intensely beautiful.

Close Your Eyes

Have you breathed in the scent of a poem,
left this leaden life behind,
walked away on a path of words?

Planting Crocus on His Birthday

I remember how life held him
in its vise-like grip
during those last hours

the way his battered body
convulsed
with each hard-won gasp

the way peace
poured into him
the moment he exhaled

the way I yearned
for his breathing
to stop.

What is that stubborn
knuckle of will
that buckles us to life.

I drop the crocus
into the opened earth

perhaps what persists in us
is like this bulb:

blossom long gone,
now back to where it began

brimming with distilled light,
it knows only one song.

Milk

This goat kicked me only once,
as if to say she knows
I'm an amateur

but leaning my head
against her rounding flank,
I love the way her need for release
matches my need for her milk,
and I remember the ferocious little mouths
that latched on to me
relieving that overwhelming, dripping pressure of too much

and it was all too much then—
the endless stream of groceries meals
bills illnesses laundry jobs no sleep—
so just to sit in the rocking chair was sweet respite,
to do this one thing:
watch the baby
drain the profusion of milk out of me
watch the baby
become so contented that nursing faded into sleep.

Now, this ordinary chore of milking generates
a similar contentment in me
the way her steady animal warmth warms me
the way my hands learn the ancient rhythm
the way the pail rings every time her milk hits it.

And a twinge of astonishment
quickens in me as well—
after you and I labored long and hard,
after we created so much together that is still so good—

how can it be you didn't live long enough
to come round to this side
where simple contentment gives birth to joy.

Pie

Skin, like piecrust, was invented
to keep our insides in
and the outside out.

Skin, like piecrust, is surprisingly tough;
stretches beyond imagining;
and can be patched with pieces of its own self,
leaving it strong in the broken places.

Thirty years ago this month, I prepared for my wedding;
Twenty years ago, I was raising three children under the age
 of five;
Ten years ago, my husband was diagnosed with cancer
and we lost him.

Tell me, to whom do we belong if not to one another?
Doesn't a longing for belonging
mark us as human beings?

The One who mixed flour and water
who fashioned us to be functional, resilient, beautiful—
that same Spirit pierces us
again and again

to let the inside out
and the outside in
that we might pray,
and change

and recognize our need for one another
and for the One who made us

that we might embody the same gravitational force
exerted by a pie, just out of the oven:
the way it pulls people out of every dark corner
with its fragrant promise of communion and joy.

II

Winter

—

"I saw also that there was an ocean of darkness and death, but an infinite ocean of light and love, which flowed over the ocean of darkness."
—George Fox, founder of Quakerism

Swing Low

It's 2 a.m.

I hold my mother's hand.
She is 92.
Apparently survived yesterday's heart attack.

Her window is open.

Strange the Being
as palpable as my mother's hand
as comforting as her breathing.

Strange the Being

who inhabits
this stillness
this way station

Dying

Our Father, who art in heaven
Hallowed be Thy name

was the way my mother learned it
so when, deep in the folds of a coma, she
heard her pastor say those words at her bedside

she rose to the edge of that prayer
and mouthed every last word

for thine is the Kingdom
the power
the glory
forever
Amen.

A Few Moments

The below is based on Erika Staub Niemi's writings in The Staub Stories: Memories of Anneliese, Erika and Henry Staub, 1933-1945 (New Brighton, MN: H.P. Staub, 2000), *page 52, edited by my father, Henry P. Staub. In this passage, she describes their experience during the bombing of Dresden. The excerpt begins with: "Suddenly the bombs stopped falling. We lifted our heads. We were still alive."*

out of the basement shelter
up to our apartment
look out the windows

sparks raining down
on neighbors' houses,
buildings in flames

a few moments
to decide
is the worst over, or still to come?
stay here, a building spared,
or flee—but where?

Grab your coats, she said
Put on heavy boots—the streets are burning
Drench towels, hold them over your nose and mouth

Keep together
Head to the Elbe
Go to the river

where perhaps
it will be easier

for us
to breathe

Whistle

—for Mamie Till Bradley

She could see it helped him
lurch off that troublesome letter,
launch the word that was stuck,

so she encouraged him to whistle.

He left from Chicago on a Saturday
with a smile and a hug
to visit his uncle in Money, Mississippi
and ten days later, she demanded
his body come back home

> his head almost cleaved in two
> one eye gouged out
> tracks of chains and barbed wire around his neck
> his body beaten,
> bloated from three days in the river.

She insisted:
an open casket
an open funeral.

Let the world witness
what those men
and the wide white web of complicity

had done to her only child,
her fourteen-year-old boy

who stuttered.

The Murder of Carol Jenkins
in Martinsville Indiana in 1972

—Eventually, two men from Indianapolis were convicted of this murder.

Isn't it good
we are made like the earth,
the way the deepest stone secrets
that sink within us—

the secrets we are bribed as children to keep,
the secrets whose very existence we deny
layer upon layer upon layer—

those stones want to rise.

It takes a frost heave
a winter turning to spring
a notice in the paper
thirty years after the murder
asking for tips

and God

you can feel that boulder
shake its huge shoulders
free from roots and muck,
and rise

such a long way
till it breaks through your abdomen
your rib cage, your breasts;
till it breaks through your fingertips
into a letter to the FBI
saying "me—I know,
me, ask me—
I can lead you to him,
the man who drove the screwdriver into her heart."

ISIS

With blood still running
from that place
that had never bled before

With her own flesh torn, shredded, ripped open
in that place
that had never been touched before

Still she found what she needed
Still her hands formed what she needed
Still she managed
—this ten-year-old girl—

to hang herself

Little
—in memory of three-year-old Alan Kurdi

Did the waves swell with sorrow
rising and rolling
peak over trough
as they relayed his little body toward land.

Did they ache with regret
to relinquish him at the shore's edge
reaching and rippling
to touch the crown of his head.

There he lies:
washed ashore
feet first
face down
right cheek turned against the sand.

again and again

the judge's gavel slams down
snuffs out a child's future

again and again
prison doors clang shut
lock a human being in a cage

again and again
bullets pierce dark skin
rip through head, through heart

again and again
blood runs irretrievably
soaks permanently into pavement

this crushing pavement
called racism in America

Praying

Knees bend.
Hands clasp.
Head bows.

The body clears a path
for the heart to follow.

Thumb

Sometimes still
my left thumb finds
the empty place

where my ring
used to circle and slide
and says,

Tell me again how this happened?

Sorrow

Happiness is brittle—
snaps at the first sign of trouble.

Sorrow is supple, resilient, loyal
the perfect lifetime companion

if it weren't so heavy.

Maple Seed

Just an accidental combination of wind and gravity
and the maple seed spiraled to a stop
right next to the chain link fence

where it could either take root
and begin,
or shrivel and die,

and so it began pressing
upward and outward against the fence
year after year

its bark doubling inward,
rumpling, dimpling,
diamond shapes

permanently imprinting in the bark,
chain links coursing through
the maple's own heartwood.

Does anyone complete
this journey from earth to heaven
unscarred?

Hasn't your heart also
been run through again and again
with what it takes to accept life's non-negotiables

and keep growing?

Verdaccio

—Verdaccio is an underpainting technique which originates from the
Italian fresco painters of the early Renaissance.

It's a beautiful day
you're on vacation
strolling along Main Street
or hiking deep in the woods
the millstone of work and worry
miraculously lifted from your neck
and still—

that dark stab of despair comes
still, the heavy knowledge hits you
that this tranquility
is only a veneer;
nothing protects you from falling,
falling fast and far.

The Old Masters knew this
their first strokes of paint always
the greenish-gray of death
—that strange color my husband turned when he died—
and only when this underpainting was complete

did the Master add the pinks and browns of living flesh
so just the right combination
of light and shadow emerge
for the hollow of cheeks, the shine of eyes, the curve of lips

the painting reflecting what life teaches us:
death rises through life
giving life its gravity and its flight.

Winter Sacrament

Ten below zero.

Twelve inches of new snow.

A half-hour before sunrise
my shoveling is the only motion
inside the stillness.

A cardinal sings.

Love
—*for Tricia*

love is as strong as death
—Song of Solomon 8:6

After days upon weeks upon months
of a losing battle
now every bit of his body is conquered,
except these last breaths.

He perches on this beloved promontory
of home and family,
and all he sees behind his fallen eyelids
is rushing, roiling river
and the water rising.

He teeters there
hour after hour through the night
daughter at his bedside

the maximum dosage of morphine not enough
to calm or comfort him
his lungs filling up with fluid
every muscle failing him.

When morning comes, his wife of 57 years
emerges from her room
and, warm from sleep, puts her arms around him,
kisses him on his lips.

And he, whose only movements for days
have been the cruel jerks of pain,
opens his eyes, looks at her,
lifts both his hands to her face.

She says, "I love you."

His arms drop.
His eyes close.

He steps out onto that rock
in the river
the waters already calming
already receding

and then
there he is
on the other side.

Be Not Afraid

I am converted and every day:

when the clouds dream
a new dream
and fill the air
with snow

when the pines and hemlocks
lift their needles
and welcome
what sun there is

when the creek,
hard frozen,
listens as the fox
trots along its side.

This world of enchantment
waits for you
like the milkweed
standing in this snowy field

its pod open wide
like angel wings outstretched
ready to catch
the rising wind.

Christmas Eve

Balancing a plate of cookies on each palm
I walk from the parking lot to the church
when a homeless man approaches me
"Looks like you have two pies there."

I smile and hold out the plates to him
"No, they're cookies—help yourself!"
He lifts a corner of the saran wrap
starts to take the smallest cookie.

"There are plenty," I say
knowing that the tables at church
will be overflowing.
"Take a few!" He takes two and then

perhaps because my hands are full
perhaps because my arms are outstretched
perhaps because he has already taken more
than he thought he could

he leans in and kisses my hastily turned cheek
"God bless you," he says.
"And you," I stutter
startled, glowing.

Word to Wing

Driving to work on a winter morning
deep in that common despair
of too much winter and too much work,
The Writer's Almanac comes on the radio

and suddenly I drop into a Jane Hirshfield poem
about resilience and trees,
so I glance up

and there is a nest,
perched in the crook of an overhanging branch,
a little bird's nest from last summer

and beyond it a squirrel's nest pops into view
and in that ungainly nest, since it's February,
there is probably a squirrel
nursing her thumb-sized young,
her spectacular tail surrounding them

and beyond the nests the sky beckons,
reminding me that soon, snow geese will return
their white wings tipped in black

beyond winter, beyond work, beyond words.

There is something about a poem that sings,
something that lifts you from word to wing.

Slow by Slow—1

Love makes your soul crawl out of its hiding place.
—Zora Neale Hurston

The ice stretches from shore to shore
catches, holds.
Now I am rock solid,
says Ice.
Let the snow come, let it go.
I am at ease.

Yet Light travels unbidden
into the darkness below
to make tender that boundary
where Ice meets water:

Do you remember your liquid self, says Light to Ice
the way you shone under the sun?

I remember being sucked dry by the heat, replies Ice.

Do you remember the open sky above you by day,
the clouds, your conversations born of rain and reflection?

I remember awful storms, says Ice
limbs of trees crashing into me,
acres of dirt and debris muddying,
slowing, obstructing my way.

How about the way the wind touched
the length and breadth of you?
The way you rippled, changed, moved under that touch?

That I remember.

The long companionship of the night?
Stars beyond imagining?
That quiet so deep it reverberates?

I remember that too, says Ice
as her grip slips off the shore
and the first red-wing calls.

III

Spring

"Love was the first motion."
—John Woolman, Quaker abolitionist

Hinge

At last the hillsides
are easing out of their burlap mantles
all brown and gray

they are yielding to swirling, rounding cloaks
of irrepressible velvet
amber and golden and green

and what shall I do
but praise this Maker
who turns with us
from the season of enduring
to the season of embracing.

Amtrak

a bicyclist in a sun-yellow jersey
rolling along a two-lane road
a man clambering up a hill after golden retrievers
open forest floor waiting for spring
red car abandoned in the woods
a house collapsing on itself

river wild with snowmelt
a fly fisherman knee deep in water
his line a spider's thread bisecting the sunlight
a killdeer arrowing against the sky
buffleheads startled into flight
Canada geese circling, landing

door standing open to a hay mow
canoe tied by a river bank
trampolines in back yards
Buddha on one hilltop
a cross on the next
brown, weather-beaten barn

girl sitting by a pond
woman on her back deck, feet up on the picnic table
someone looking out the screen door of their trailer
smoke from a smoker
Trump poster
a solar array curving along a hillside

junk yard
sugar houses
golf course
three overweight men in white tee shirts
sitting in a garage watching the train—
then graffiti: Dog boy loves Cat woman.

So slowly we are almost floating, we pull in to the station.

Naked Hour

"Hold still," my mother said to me
and I repeat the phrase to my little ones
as I kneel to dry their plump and wriggling bodies

while they eye the door through the steamy air,
spring-loaded as they are for their escape
the moment a rush of cool air greets them

and they dash into the hallway
 gallop from bathroom to kitchen
 whooping their way through living room,
 dining room, bedrooms, den

knowing, even then, that Naked Hour
 was fun of a different order:
 when rules, like clothes, drop to the floor
 when permission sails in on a breeze
 when your own unfettered body
 shows you the way.

Two Poets

—or, why English is such a difficult language to learn—

Hey—we've been passing like ships in the night.
Can't we hang out together
and make beautiful music like we used to?

You must have lost your marbles, she says.
You need to turn on a dime
and step up to the plate
if we're going to make hay while the sun shines.

Wait a minute—you're putting the cart before the horse.
Let me cut to the chase.
We've been treading water, and all I'm trying to do
is move the ball down the field.

I know, she says, but you have to have
your oar in the water too.

Look, he says, you're my north star.
I know I missed a few beats, but
don't throw the baby out with the bath water.
I've turned over a new leaf.
I'm watching my p's and q's.
I'm dotting my i's and crossing my t's.

Now we're cooking with gas, she smiles.

I'm so relieved. I was afraid you had hung me out to dry.
If we can be like two peas in a pod again,
everything else will be icing on the cake.

Ode to Salted Caramels

—a thank you note to my son

Terribly sticky
and awfully sweet,
caramel alone can't possibly compete

against caramel with salt
a luscious combination
that carries within it a gritty affirmation.

What holds true for caramel
is also the case
in love, in art, in all that we face:

the rose has its thorns
the heart, its head
everything beautiful
requires an edge.

Progress

I did not just drag and drop.
I did not just haul a burden so heavy
that my hands, arms, and shoulders
gave way
and I had to let it go.

Neither did I just browse.
I did not get on my hands and knees
and join the gentle cows
to slowly sample
whatever the open field had to offer.

Instead, I sat here at my desk
manipulating a mouse
which is not, in fact, a mouse
and I searched
for something on the web
that is not, in fact, a web.

And isn't this how we move forward:

with horsepower for jet engines
and candlepower for light bulbs
we take what we understand from one era
to describe
what we don't
in the next.

Slow by Slow—2

"Secret work has been done in us of which we've had no inkling."
—John O'Donohue

It's like yeast, they say
or a mustard seed

but I submit
it is also like carpenter ants

the way they work, hidden,
unbidden, unnoticed,

deep within the foundation, the walls,
the very structure of the house

so that one day
light filters through
where a thick wall stood

one day
you see a patch of open sky
where the hardest ceiling had been

one day a door
stands ajar that has been
locked for a lifetime.

Slow by slow
grace finds a way.

Slow by slow
still the gift comes.

Mercy

How is it that guilt
which has no substance
should be so heavy

and forgiveness
which has no substance
should be so light?

Measurement
—for Barbara and David Wright

I slept from 10 p.m. last night until 8:27 this morning.
Ten hours and twenty-seven minutes.

Yesterday I drove 328 miles to visit my sister in Princeton, NJ
the home of Albert Einstein
who captured energy, mass, and the speed of light
in an elegant equation every student learns.

Look at us:
we quantify everything we can
in this complex and astonishing world,
 nanoseconds to eons
 millimeters to miles
 basis points to billions.

But no one can measure the velocity of hope,
 the way hope hatches
 fully fledged—already flying—
 between one word and the next
 between one breath and the next.

Neither can we calculate the stain of fear,
 the way it infects a childhood
 spreads to a lifetime.

And we can only try to imagine the circumference of compassion
 the way it shows us the shape of love
 embracing, expanding,
 factoring in forgiveness
 it invents its own quantum leap,
 its own speed of light.

Birding by Ear

It's like praying.
Bow your head.

Listen.

One small voice
within the cacophony.

Sometimes the song.
Sometimes the call.

Can You Imagine

(three haiku)

the interstitial
tissue between thorns and sky
is Jesus, the rose?

But to believe this,
the intellect must embrace
what it cannot grasp.

Faith, like poetry,
is the mind loving the heart,
its opening worlds.

Jesus Buys a House
in South Burlington, VT

I live in a lovely neighborhood
or at least it used to be,
before he moved in next door.

Now there's a stream of raggy people
on bikes, in cars, most trudging up the street on foot
to his raised ranch.

Those old unkempt men who live
under the bridges and back in the woods.
Those women, streetwalker-types,
and old ones with walkers or canes.
Children too, and
migrants, immigrants, illegals, college kids
all the riffraff
plus a few decent people
some fancy cars mixed in.

And he feeds them.
Has an old Weber grill
set up in the front yard.

I called the police
and saw them pull up—
I thought they would shut down the operation—
but apparently he's not breaking any laws
not even disturbing the peace
and today the paper reported
that the officers resigned from their positions
and moved in with him.

And it's true—I've seen them working
side by side with the others
serving food
cleaning up
weeding that big garden in the front yard.

The article didn't include what Jesus *said*, though,
that made those officers leave good jobs to stay with him.
What does he *say* that makes all those people want to be
 near him?

Every night he builds a bonfire out front.
Stands there in the light with everyone gathered around him
and I have to tell you—

I don't know why I'm doing this,
I'm not the kind of person who does this kind of thing—
but here I am, standing in my bedroom next to my open window
to listen.

Boulder

All grimy hands and skinned shoulders,
two men pushed me into place,
their curses and grunts
grim testimony
to the finality of their task.

Long after they left
on this unsettled night,
—how can I describe it—

a warmth?
a blossoming?
something like dawn?
yes, something undeniable like dawn
reverberated through me

and I found myself
doing the impossible:
I rolled away from the entrance to the tomb.

In the darkness before sunrise
Jesus leaned
his frail and bloody frame against me,
struggled to pull
new breath from the night air.

To die—yes—he consented
To rise—yes—it had been foretold
but to inhabit again that needy body, that carapace of pain?

How little we know of what
Love will ask of us
when heaven touches earth.

Staple

—for Yona Yellin

I love a staple:
its precision, its usefulness
the way it tidies up whatever it touches.

The hope a staple gives us
—along with its cousin the paper clip—
that orderliness, even perfection, is within our grasp.

And if you think, like I used to,
that order is overrated;
if you think that it's stifling, constricting, severe,
I hope you come to College Street Church
and listen to the organist

so you can experience the way
an exact time signature
sculpted dynamics
and thousands upon thousands of precisely placed notes
give way to perfection

the kind of perfection worth reaching for
the kind that enters you
with a stab of glory

pulls you toward itself
before pushing you out
into the Light.

Teach Me About Trust

Watch the fledging
hop and stutter
work its way
from nest to branch.

Watch the fledgling
flap and flutter
risk that distance
from limb to limb.

Watch the fledgling
tip and tumble
drop to the ground
from there to struggle

until at last
sky over sky
wing over wing
gone

Mallards

The momma mallard knows as well as anyone
the slicing teeth of the northern pike,
the viselike grip of the snapping turtle,
the deadly silence of the mink.

Yet she waddles from the bank, sinks happily into the water
and nine ducklings tumble in after her
—those perky puffs of delight—
scooting forward and back around their mother.

There are thousands of ways to step out in faith
and surely this is one of them
to venture into this world
of viciousness and tenderness.

Though we remember the times
the snapping turtle rose from the bottomlands,
though we are still lost in a lake of emptiness
trying to capture ripples,

yet, like the mallard,
we amble out of our nests
into the day
expecting our precious children to do the same

to venture forth
counting on tenderness

knowing in our bones
that none of us, not one,
was born to stay on land.

Sounding

It is no voice
but a certainty:

this is how to fly—
let go

IV

Summer

—

As if I asked a common Alms
and in my wondering hand,
a Stranger pressed a Kingdom,
and I, bewildered, stand—

—Emily Dickinson

Trees

—for Eves and Iola Cadwallader,
who planted over 4,000 trees in their lifetimes

Let me learn the language of trees

the patient and probing register of roots in summer
their thousand words for thirst,
for texture, for search.

Let me learn the cadence that carries
wordless sustenance
from tendril beneath to trunk, to limb, to leaf.

Let me learn the long and laughing language of leaves
their thousand words for wind and light,
the sound of raindrops through the night.

Let me learn this language of trees
the better to pray, the better to praise.

Comfort

If you have a grief as big as mine—
and if you love in this world
I'll bet you do—
come to southwestern Kansas
stand in the wheat fields
near a town aptly named Plains.

Feel the way that vast Kansas sky
changes solitude into loneliness
in a heartbeat
the way loneliness morphs into sorrow

a sorrow as heavy as it is invisible
a sorrow with no room for anything but itself.

You can build a house out of this kind of sorrow.
You can line its walls with resentment.
Paper over its doors and windows with bitterness.
You can live in this sturdy, narrow house
a long, long time.

Or—you can let your eyes travel
over the bounty of the wheat fields.

You can notice the way
they stretch to the horizon
the horizon so far away
the sky has to bend down to reach it.

And it does.
See how decisively, definitively
it reaches for the earth.

Time

It's not the sunrise itself—

but the slow ripening pleasure of hanging clothes on the line
the simplicity and certainty of the clothespin

it's the unstinting sun on my shoulder
the wind that snaps and crows.

And it's peeling peaches
slicing their glowing flesh

measuring flour, rolling pie crust,
the fragrance of baking filling the house.

It's the way the ordinary reveals its grace
when a morning moves at its own pace

—that replaces my darkness with light.

Recipe

Jockeying for position with a sister or two,
I watched my mother
pour water into the Pyrex measuring cup,
lean down to eye the two-cup line,
drop in slathers of shortening
until the water rose to the four-cup level.

With the art of water displacement,
the sifting of flour,
the scrape of the straight edge
across a teaspoon of soda and a teaspoon of salt,
how well she taught us
the importance of precision.

And when she abandoned the recipe,
reached over our heads
for the bag of chocolate chips
and dumped all of it
into the thick and creamy batter,
how well she showed us

the surpassing value of joy.

Remember

There is no such thing as quantity in love
my mother said, correcting me.

No such thing as "much" love.
You can't count it.

No such thing as "all my love."
You can't contain it.

Love expands.
There's an endless supply.

I love you, she said.
That's sufficient.

Looks

Perhaps everyone else has forgotten it,
but in the days when my mother
poured her midsection into a girdle;
when she gathered her nylons into flimsy donuts
before unrolling them, up one leg and then the other;
in the days when we, her daughters,
fastened bulky sanitary napkins
to sanitary napkin belts,
there was Dippity Do.

My mother dabbed the greenish blue gel from the jar,
reached up and slid a section of hair through her fingers,
then wound the hair around a bristly curler,
securing it with a plastic curler pin
against her scalp.

Now, my daughters trap and pull their naturally wavy hair
through the jaws of a straightener
so that their hair might be "as straight as a pin"
which is exactly the way
my mother used to describe her own hair
and, with a sense of tragedy, mine as well.

I don't know who decides whether curly or straight
is the right look for hair
and I can't say that I care,
but what matters to me still

is the way the light changed in my mother's eyes
as her gaze shifted
from her own reflection in the mirror
down to mine;
the way her exasperation eased
with the hair, the Dippity Do, the curlers;
the way the wrinkles over her cheekbones deepened,
and a smile emerged
as if we were co-conspirators,
co-creators, in some grand drama

as I handed her another curler,
another pin.

Mothers

Just leaving with my groceries
I hear a baby screaming

so I pivot toward the sound
and next to the returnables machine
is a young mother depositing can after can,
her infant in a car seat on the floor
his little ear inches away
from those apocalyptic sounds.

May I hold the baby
while you do that?

She doesn't respond, keeps depositing the cans.
I crouch down and rock the infant seat,
the baby screaming.

She looks back and forth between the baby,
her trash bag full of returnables,
and me.

May I deposit the cans
while you hold the baby?
I look up at her, my voice trembling.

I am overcome
with love for this young woman
caught, as I have been so many times,
between getting something done
and the needs of a baby.

She says nothing, but stops.
Bends to the car seat,
rocks it with her hand, then speaks to the child,
opens the straps and buckles,
lifts him out of the seat

curls him into her arms and neck
juggles him softly against her,
murmuring to him
his little body wracking with sobs,
then quieting.

Look at how he calms down
she says, looking at me with a little smile
not all babies do that, you know.

How old is he? I ask.

Two weeks, she says.

He's a beautiful baby.
Is this your first time out with him?

Yes. I saw that big bag of cans on the porch this morning
and I thought today's the day to get rid of that.
But I didn't know how hard it would be.

Yes, I say, it's impossible to do anything
in those early weeks.
May I feed the machine while you hold the baby?

ok she says.

so I do.

A Mother's Response

—*after "The Lanyard," by Billy Collins*

On that rainy summer afternoon
when you wandered into the craft area at camp,
you didn't make a snake out of lanyard;
you didn't make a noose, or a whip, or a belt for yourself—
you made something for me.

And as you struggled to weave the red and white strands
over and under and back and forth,
it is quite possible
that you thought about me:
the note I left for you in your pants pocket
the chocolate chip cookies I sent.

In addition, you did not lose
that lanyard before you got home.
You saved it.
You remembered to give it to me.

So when I weigh
what I gave to you:
a breathing body,
a beating heart,
thousands of meals,
a good education
against what you gave to me:
 acres of laughter
 your big brown eyes and coppery hair
 the way you expanded my life
 like water expands a tightly compressed sponge
I think we're even too.

Except for that lanyard

—which, by the way, I kept
in my top drawer for decades—
with that lanyard, you win.

Kiki

I am only fifty
and already chockful of memories
none more precious than Kiki's kitchen
when she asked me
to go find an egg
and I ran and leapt and bounced out of the house
through the thick Missouri heat
past the asparagus patch
and the tomatoes hanging heavy
to the grape arbors
and stopped.

Lifted the iron latch to the chicken house.

Stepped into the dark.
Dust, feathers, cobwebs, clucking suspended in the still air.
Searched the nests, the corners, any tuft of straw
until I found
an egg
a brown egg
a warm brown egg
that fit perfectly in my hands
felt smooth against my cheek.

I walked back carefully
to that sunlit kitchen
where Kiki
—all surprise—
reached for it with her soft, cool hands
accepting this egg from my sweaty and grimy ones
with such care and reverence
as if she knew
what it held.

Judge

I counted the wrinkles
from the corner of his mouth to his big ears,
arriving at four or five
before he snarled and snapped at my hand
and I hopped off his lap,
delighted.

He counted my ribs
starting from the bottom
wiggling his finger against each bone.
He would get to three or four
before I collapsed in a fit of giggles
and ran off.

He told stories to us six sisters about the fearsome Kiki,
his wife, our grandmother,
roughly half his size and weight,
how she marched him to the basement,
hung him up on a nail, and whipped him.
And why did she do such a thing?

He gathered us close
around his chair
and, after our solemn promise
never to tell Kiki,
his false teeth came riding
out of his mouth on his tongue.

We exploded, screaming and laughing,
until Kiki came around the corner
from the kitchen in her apron,
shot Judge that particular look
from behind her rimless glasses,
and murmured, "Now, Badith . . ."

Why she called him Badith
we never knew.
His name was Henry John Westhues.
Chief Justice of the Missouri Supreme Court
but when he was in trouble with Kiki

—for popping out his teeth
or gleefully reciting a poem
that had "hell" or "damn" in it—

she called him Badith
and he slapped his knee
with his big farmer's hand,
leaned back in his chair

and smiled up at her.

Map

Reaching back from the front seat while Mom drove,
my dad showed us the series of two-lane roads we would
 travel
from our home up north in Minneapolis,
to Judge and Kiki's house
down south in Jefferson City.
He challenged us to add up the miles
between the pinhead markers on the map
and find the exact spot
where our red station wagon was right at that moment,
loaded with the eight of us, our dog, our food, our suitcases.

I loved the names of the towns we rolled through
Owatonna, Oskaloosa, Ottumwa
and I enjoyed the map games,
but folding that map
utterly mystified me.
I would try every which way before giving up and
handing a bulky square, creased down the middle, to the
 front seat
where my father would spread it out in the air in front of him,
deftly pop in and out the folds
until the map collapsed into his hands
of its own accord.

Now forty years later,
he and I wait for my mom to get out of surgery,
and we pore over a map
to find a better way home,
and I trace for him the route I have chosen
from 494 East to 35W North to 11th Street
and he studies this for a long time
before he moves his index finger along the thick green line
that bisects Minneapolis and says,

"Now, is this what you call north?"
"Exactly," I say.
Satisfied, he creases the map down the middle
and hands it to me.

I don't re-fold it.
Now 89 years old,
he's been married since he was 30,
practiced pediatrics until he was 80,
raised six daughters,
escaped from the Nazis in his youth
and survived a stroke in his old age.

That map, just as it is,
is accomplishment enough.

Letting Go

Other kids described
bloody tennis rackets
and victory when the corpse
was tossed into the trash,

but my dad donned heavy leather gloves
found the thickest towel
waited until the bat settled
upside down

then climbed a step stool
balanced there
enfolded the creature in the towel
with both his hands.

We six sisters ran ahead
held the door open wide
and he let the bat
go, go
into the welcoming dark.

Such a wondrous thing
to end up in my father's gentle hands.
Such a thing to envy
a father's hands guiding the little one
into that undulating, reverberating expanse
where she could find her own way.

Paradise of Light

In thy long Paradise of Light
No moment will there be
When I shall long for Earthly Play
And mortal Company—
—Emily Dickinson #1145

Behind the Green Mountains
comes a flush, a command
of crimson and rose and apricot
to break open the day

the colors resound
over miles of open sky
to the Adirondacks
where crimson and rose and apricot reply.

And in that long paradise of light
there is no blade of separation
fine enough to distinguish the point at which
one color ends and the other begins

the same way love loves to change us
from what we were
into something new

the same way love loves to lead us
into colors and cultures and creeds
not our own

the same way love loves to keep creating
this long mystery,
still unfolding, still emerging,

still as strong as light.

Shine

After the first bus comes and picks up
a dozen passengers,
I'm alone at the bus stop

when an older man approaches me
drooling, dressed in a bright-yellow crossing guard vest
his clothes stained, hanging loose from his frame

says Do you have a dollar to spare
Yes, I certainly do, I say
and reach into my bag

...such watery blue eyes he has
and what makes a person drool like that...

Do you believe in God he asks
as I glance down to my wallet to avoid
the ten or the five
I say, yes, I certainly do

and when I look at him again
he has straightened up,
and there, beside Shelburne Road
and its four lanes of traffic in rush-hour frenzy,

He makes a sweeping sign of the cross
as high as he can reach
as wide as he can stretch

and says, looking at me
God bless you
and Jesus too.

Then he takes the dollar in his
rough, misshapen hands
and walks down the block, crosses the street

that safety vest shining the whole way.

On the Bus

One foot raised, I'm boarding the bus, and suddenly the person ahead of me cries out with delight, "You're back!" and throws her arms around a man seated in the first row. He's the retired bus driver, back to ride the route between Burlington and Montpelier that he drove for years.

When we are underway, he stands and addresses the riders:

"And now, if it is okay with everyone, I'll do what I used to do and recite the Gettysburg address. Remember President Lincoln spoke these words to remind the nation that all people are equal and we are one nation:

Four score and seven years ago our fathers brought forth on this continent a new nation, conceived in liberty, and dedicated to the proposition that all men are created equal.

Now we are engaged in a great civil war, testing whether that nation, or any nation so conceived and so dedicated, can long endure. We are met on a great battlefield of that war. We have come to dedicate a portion of that field, as a final resting place for those who here gave their lives that that nation might live. It is altogether fitting and proper that we should do this.

But, in a larger sense, we cannot dedicate, we cannot consecrate, we cannot hallow this ground. The brave men, living and dead, who struggled here, have consecrated it, far above our poor power to add or detract. The world will little note, nor long remember what we say here, but it can never forget what they did here. It is for us the living, rather, to be dedicated here to the unfinished work which they who fought here have thus far so nobly advanced. It is rather for us to be here dedicated to the great task remaining

*before us—that from these honored dead we take increased
devotion to that cause for which they gave the last full
measure of devotion—that we here highly resolve that these
dead shall not have died in vain—that this nation, under
God, shall have a new birth of freedom—and that govern-
ment of the people, by the people, for the people, shall not
perish from the earth.*

Now I'd like us all to say those last lines together and say
them so loud that the folks in Washington will hear us:

*that government of the people, by the people, for the people,
shall not perish from the earth.*

and while I have your attention, I want to thank everybody
for riding the bus
because you are doing so much for the planet."

On the ride home, the bus almost empty, a thirty-ish man
got on, with ill-fitting, stained clothes and greasy long hair.
He looked around for a place to sit, and chose the seat just
ahead of mine. Then a twenty-ish woman got on, looked
around for a place to sit, and chose the seat right next to
his.

They chatted.
She got out a Kit Kat bar.
He got out a bag of chips.
They shared.

Late August

Finally the sun relaxes its grip on the day.
Allows its uncompromising glare to relent

and the day's edges to soften.

Afternoon forgets the exuberant promise of Sunrise.
Without fanfare, it abandons
Morning's bright and brassy plans

sinks into its own wholeness

to float for a while
on the slow wings of summer.

Reverence

The air vibrated
with the sound of cicadas
on those hot Missouri nights after sundown
when the grownups gathered on the wide back lawn,
sank into their slung-back canvas chairs
tall glasses of iced tea beading in the heat

and we sisters chased fireflies
reaching for them in the dark
admiring their compact black bodies
their orange stripes and seeking antennas
as they crawled to our fingertips
and clicked open into the night air.

In all the days and years that followed,
I don't know if I've ever experienced
that same utter certainty of the goodness of life
as palpable as the sound
of cicadas on those nights:

my sisters running around with me in the dark,
the murmur of grownups' voices,
the way reverence mixes with amazement
to see such a small body
emit so much light.

ACKNOWLEDGMENTS

Heartfelt thanks to Suzi Wizowaty and to David Budbill, for their early mentoring and support of my poetry; Mark Burrows, whose encouragement continues to inspire me; Iola Cadwallader, my late husband's mother, for her steadfast love; and to my children, who are the wellspring of my joy.

The quotation from "The Lanyard," set in italics on page 74, is taken from Billy Collins, *The Trouble with Poetry*, trade paperback edition (New York: Random House, 2007), 45.

Thanks are also due to these journals and publications in which poems from this collection first appeared:

"*Ave Verum*," "Verdaccio," "Planting Crocus on His Birthday," "Comfort," and "Maple Seed," in *Arts*

"In Whom We Live and Move and Have Our Being," in *Birchsong*

"The Murder of Carol Jenkins in Martinsville Indiana in 1972," in *The Comstock Review*

"Route 100," in *Connecticut River Review*

"Longing," in *DreamSeeker Magazine*

"Reverence," in *Friends Journal*

"Milk" and "Comfort," in *Hunger Mountain Review*

"Be Not Afraid," "Moth," and "Slow by Slow," in *Kingsview and Co* (extending *Dreamseeker Magazine*; electronic only)

"Can You Imagine," "Blackbirds," and "Pie," in *The Mennonite*

"Mallards," in *Passager*

"Word to Wing," "Recipe," "Lesson Before a Road Trip," "Winter Sacrament," "Ode to Salted Caramels," "Two Poets," "Staple," "Winter Sacrament," and "Letting Go," in *Poem Town: Randolph*

"Turning," in *Potomac Review*

"Measurement" and "Trees," in *Spiritus*

"Midlife," in Vermont Poetry Broadside Contest

"Reverence," "Map," "Looks," "Midlife," "Progress," in *The Writer's Almanac* (electronic only; aired, respectively, on June 6, 2009; March 22, 2011; May 24, 2012; October 21, 2012; December 7, 2013)

About Paraclete Press

Who We Are

As the publishing arm of the Community of Jesus, Paraclete Press presents a full expression of Christian belief and practice—from Catholic to Evangelical, from Protestant to Orthodox, reflecting the ecumenical charism of the Community and its dedication to sacred music, the fine arts, and the written word. We publish books, recordings, sheet music, and video/DVDs that nourish the vibrant life of the church and its people.

What We Are Doing

Books

PARACLETE PRESS BOOKS show the richness and depth of what it means to be Christian. While Benedictine spirituality is at the heart of who we are and all that we do, our books reflect the Christian experience across many cultures, time periods, and houses of worship.

We have many series, including *Paraclete Essentials*; *Paraclete Fiction*; *Paraclete Poetry*; *Paraclete Giants*; and for children and adults, *All God's Creatures*, books about animals and faith; and *San Damiano Books*, focusing on Franciscan spirituality. Others include *Voices from the Monastery* (men and women monastics writing about living a spiritual life today), *Active Prayer*, and new for young readers: *The Pope's Cat*. We also specialize in gift books for children on the occasions of Baptism and First Communion, as well as other important times in a child's life, and books that bring creativity and liveliness to any adult spiritual life.

The MOUNT TABOR BOOKS series focuses on the arts and literature as well as liturgical worship and spirituality; it was created in conjunction with the Mount Tabor Ecumenical Centre for Art and Spirituality in Barga, Italy.

Music

The PARACLETE RECORDINGS label represents the internationally acclaimed choir *Gloriæ Dei Cantores*, the *Gloriæ Dei Cantores Schola*, and the other instrumental artists of the *Arts Empowering Life Foundation*.

Paraclete Press is the exclusive North American distributor for the Gregorian chant recordings from St. Peter's Abbey in Solesmes, France. Paraclete also carries all of the Solesmes chant publications for Mass and the Divine Office, as well as their academic research publications.

In addition, PARACLETE PRESS SHEET MUSIC publishes the work of today's finest composers of sacred choral music, annually reviewing over 1,000 works and releasing between 40 and 60 works for both choir and organ.

Video

Our video/DVDs offer spiritual help, healing, and biblical guidance for a broad range of life issues including grief and loss, marriage, forgiveness, facing death, understanding suicide, bullying, addictions, Alzheimer's, and Christian formation.

Learn more about us at our website:
www.paracletepress.com
or phone us toll-free at 1.800.451.5006

SCAN
TO
READ
MORE

You may also be interested in...

Eye of the Beholder
Luci Shaw

ISBN 978-1-64060-085-0 | $18

"Luci is like the great oak tree she describes, her poetry an abundance of acorns, and we the harvesters, squirreling away the treasures."
—SARAH FAULMAN ARTHUR

Pilgrim, You Find the Path by Walking
Jeanne Murray Walker

ISBN 978-1-64060-008-9 | $18

"Proves that the sonnet form can provoke new levels of meaning, enrich language usually unheard, and uncover images invisible to the casual viewer."
—JILL BAUMGAERTNER

The Yearning Life
Regina Walton

ISBN 978-1-61261-863-0 | $18

"These pages call us to consider our lives as 'lent by the mystery and borrowed back,' as the poet puts it, showing us what yearning might require—and yield."
—MARK S. BURROWS

Available at bookstores
Paraclete Press | 1-800-451-5006
www.paracletepress.com